759.3 And Anderson, Janice. The art of the expression

THE ART OF THE EXPRESSIONISTS

Janice Anderson ___

A Compilation of Works from the BRIDGEMAN ART LIBRARY

UN -- 1996

SHOOTING STAR P

SALINE DISTRICT LIBRARY Saline, Michigan 48176

Expressionists

This edition printed for : Shooting Star Press Inc. 230 Fifth Avenue – Suite 1212 New York, NY 10001

Shooting Star Press books are available at special discounts for bulk purchases for sales promotions, premiums, fund-raising, or educational use. Special edition or book excerpts can also be created to specification. For details contact: Special Sales Director, Shooting Star Press Inc., 230 Fifth Avenue, Suite 1212, New York, NY10001

© 1995 Parragon Book Service Limited

ISBN 1-57335-113-X

All rights reserved. No part of the publication may be reproduced, sorted in a retrieval system, or transmitted in any way or by any means, electronic, mechanical, photocopy, recording or otherwise, without the prior permission of the copyright holder.

Printed in Italy

Editors: Barbara Horn, Alexa Stace, Alison Stace, Tucker Slingsby Ltd and Jennifer Warner. **Designers**: Robert Mathias and Helen Mathias **Picture Research**: Kathy Lockley

The publishers would like to thank Joanna Hartley at the Bridgeman Art Library for her invaluable help.

THE EXPRESSIONISTS

EXPRESSIONISM WAS NOT ONLY a movement in art but a way of life, though the name has become associated mainly with the work of groups of artists in Dresden, Munich and Berlin. The term was first used in about 1910-11; after the First World War it became a way of describing a particular approach to life and creative work.

The first 'Expressionists' were a group of architectural students in Dresden who felt, as did many of their young contemporaries, that the stultified society of the Germany of Wilhelm II's reign should be changed to meet the needs of the youth of the day.

Dresden was a great cultural centre, ideal as a base for the new movement. It was here that four architectural students, Eric Bleyel, Ernst Ludwig Kirchner, Eric Heckel and Karl Schmidt-Rottluff founded a group to which were soon added Emil Nolde and Max Pechstein.

Kirchner, who was the manager and spokesman for the group, put forward their aims in a manifesto which said, among other things, 'We believe in development and in a generation of people who are both creative and appreciative... We want to acquire freedom for our hands and lives, against the will of the established older forces.' Fine words from youthful idealists but difficult to put into practice throughout society, though easier through the arts which, being a means of communication, would help to disseminate the message.

Thus the group concentrated on painting as a means of bringing about the spiritual change they hoped for in society. They needed a hero figure of the past to inspire them and chose Vincent van Gogh. Both as a painter and as a man, van Gogh represented everything they subconscious layers of the mind from which came the subjective reactions which the Expressionists sought to capture, there were the artists Kokoschka and Schiele.

As Expressionism was a way of feeling rather than simply an artistic movement, many other artists from other countries are now recognized as Expressionists. Many resided in Paris, including the Russian Jew Marc Chagall, whose cultural origins made him respond naturally to his emotional reactions before a painting subject. Another was Chaim Soutine whose spontaneous handling of paint and his passionate feeling for the underdogs of society created original and memorable work. Maurice de Vlaminck, a one-time bicycle racer, was another with an instinctive feeling for uninhibited painting in a Fauve manner.

The Frenchman Georges Rouault, who had produced stained-glass windows, was different in that his passion and motivation came from a deep religious belief and a hatred of hypocrisy and cruelty.

Most artists with Expressionist leanings have continued to paint in a figurative manner. Among the most talented and impressive of them has been Francis Bacon with his tortured Popes, nudes, dogs and selfportraits, and Lucian Freud, whose closely observed and realistic studies are a reminder of Egon Schiele's dictum that all living things are dead. believed in: he had been a freethinker, though one with deep religious feelings about life; he had been a champion of the victims of society; he was an original artist who had created his own pictorial language for the direct expression of his subjective feelings; and he had believed in artists working together as a community.

With van Gogh as their hero, the Dresden artists established themselves at 65 Berliner Street, Dresden, where artists were invited to paint together, listen to poetry readings and discuss their aims. The group adopted the name 'Die Brücke' – a symbol of their hope of building a bridge between the old and the new. It was an idealistic venture and succeeded in establishing a Dresden Expressionist style which continued even after Die Brücke disintegrated and the artists moved to Berlin.

From the point of view of making an impact Berlin was important to the young artists; it also changed their outlook, as the hard, self-seeking life of the city washed over memories of the easygoing life of Dresden and the Moritzburg Lakes where the artists had gathered with their models. The outbreak of war in 1914 brought further changes. Though at first artists had greeted the war with nationalistic fervour and the expectation that it would further their cause in changing society, the reality of life in the trenches was too hard to bear and brought them death, nervous breakdowns and the dissolution of their group.

While Die Brücke had been growing and exerting its influence, another group in Munich was also developing its own form of Expressionism. Artists in this group included Wassily Kandinsky, Franz Marc and Alexei von Jawlensky. Much more loosely united than Die Brücke, the Munich group, which called itself *Die Blaue Reiter*, did not issue manifestos explaining its aims, though Kandinsky wrote books on art and its significance. Yet another group of the period was made up of Rhenish artists such as Macke and Campendonk, while in Berlin artists like Beckman and Dix as well as the survivors of Die Brücke carried on and expanded the Expressionist theme. In Vienna, capital of Austria and home of Sigmund Freud, pioneer in the analysis of the

▷ **Pollarded Willows and Setting Sun** 1888 Vincent van Gogh (1853-90)

Oil on canvas

VAN GOGH, WITH MUNCH and Ensor, was a major inspirer of the Expressionist movement, not only from a technical aspect but, more significantly, as a mood setter. In his withdrawal from the Paris scene to his studio at Arles, van Gogh seemed to the Expressionists a symbol of the independent artist in search of a communion between his own soul and the universe. In this early example of the superb paintings that he produced in the last two years of his life, van Gogh has expressed his powerful feelings about the sun as the source of life, contrasting it with the leafless pollarded willows which it will restore to life in the spring.

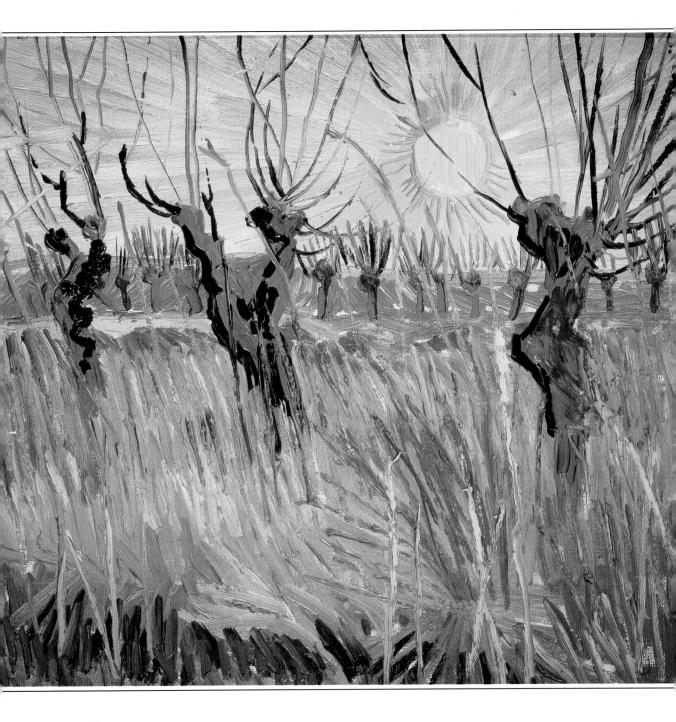

▷ **Starry Night** 1889 Vincent van Gogh

Oil on canvas

THE YEAR BEFORE he shot himself van Gogh painted this significant picture of a brilliant night sky over St Remy-de-Provence where he was a voluntary patient in an asylum after his first mental breakdown at Arles. During the year he was here van Gogh painted with feverish energy, producing most of the paintings now considered masterpieces. This painting is in the nature of a statement about his view of the universe, which he believed to be governed by unknowable God-created forces in which man and nature had to work together as parts of the whole. Though van Gogh had drifted away from the conventional religious views of his father, a Dutch pastor, a religious view of life was deeply rooted in his personality and inspired his work.

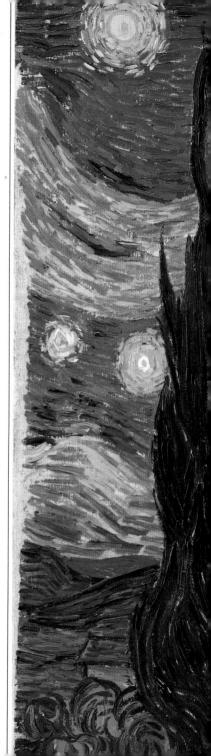

▷ **Two Skeletons Fighting over a Dead Man** 1891 James Ensor (1860-1949)

© DACS 1995

Oil on canvas

THE BELGIAN ARTIST James Ensor often painted masks and skulls and skeletons dressed in ragged clothes, rather like children dressed in clothes found in old attic trunks. He had perhaps inherited this love of the gruesome from Hieronymous Bosch or Jan Brueghel, but whereas their visions concealed political criticism, Ensor's work was a more general comment on life. Like Edvard Munch, Ensor was a very subjective painter turned inward on himself and his

inner visions. In this, he was quite unlike van Gogh, who was able to see life as a joyful experience, despite his personal tragedy. In this painting of two skeletons fighting over a hanged man, done in the midst of the phase when he used masks for human faces. Ensor indicates his recent discovery of Impressionism, little of which was known in 1880s Belgium. This allowed him to use brighter colours and more expressive features on the characters in his paintings.

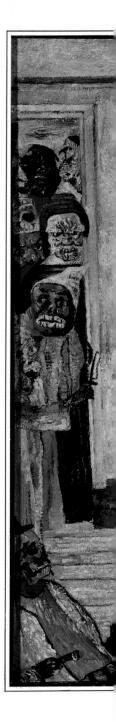

12

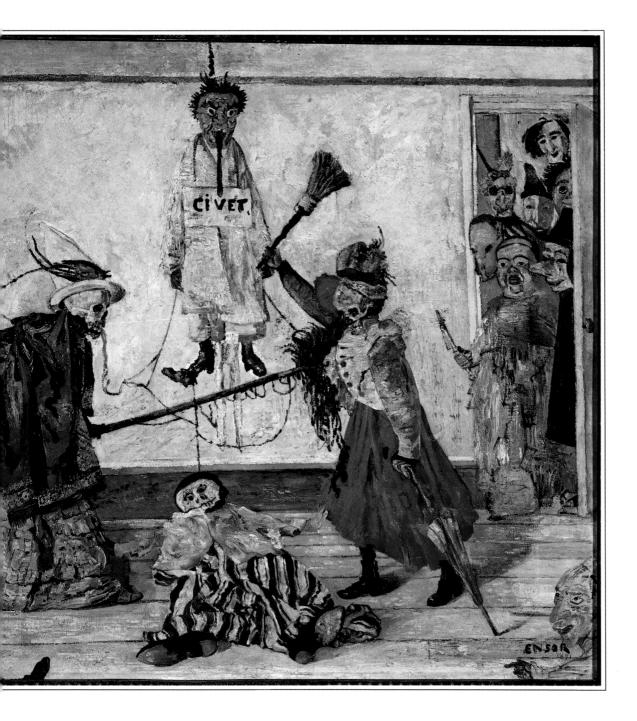

▷ The Skate 1892James Ensor© DACS 1995

Oil on canvas

JAMES ENSOR HAD A STRANGE and original mind full of macabre visions which he painted with a subjective directness and power. His work foreshadowed that of the Expressionists, not so much because of its subject matter as because of his psychological approach, which was the antithesis of the joyful art of the Impressionists and PostImpressionists. In this painting, reminiscent of a painting of a skate by the 18thcentury artist Chardin and even more so of one which Chaim Soutine painted in the early 20th century, Ensor has given the fish and the shell on the left an anthropomorphic quality which distances it from the objectivity of still-life artists like Chardin.

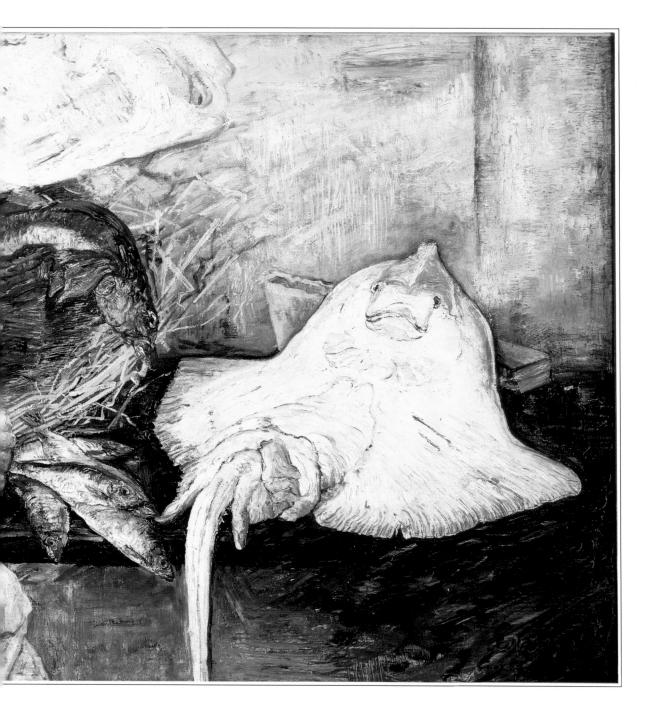

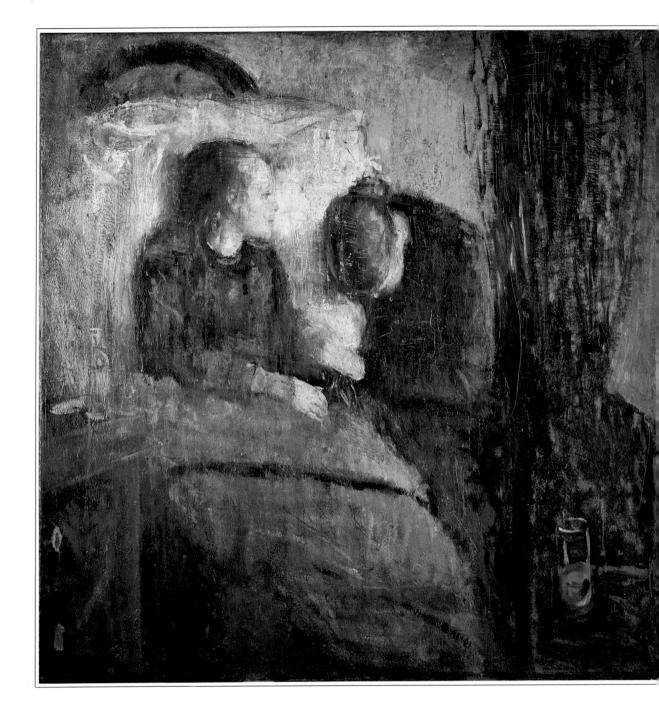

✓ The Sick Child 1885 Edvard Munch (1863-1944) © THE MUNCH MUSEUM/ THE MUNCH-ELLINGSEN GROUP/DACS 1995

Oil on canvas

EDVARD MUNCH WAS BORN in Løten, Norway and from early on in his life had more than the usual contact with illness; his father was a military doctor and his mother and sister both died of tuberculosis. This left a mark on the sensitive youth who, after beginning studies as an engineer, decided that his true vocation was painting. When he was 22, Munch went to Paris where he met many of the artists of the period and began to formulate his own ideas about his aims in painting which he later summed up as an ambition to paint human beings who breathe, and feel and suffer and love. He exhibited at the Salon d'Automne and was severely criticized, but this did not deter him and he continued to develop the style which was essentially Expressionistic in its soulsearching despair.

Spring Evening in Karl-Johann Street, Oslo 1892 Edvard Munch (1863-1944) © THE MUNCH MUSEUM/THE MUNCH-ELLINGSEN GROUP/DACS 1995

Oil on canvas

\triangleright Overleaf pages 18-19

MUNCH'S INTENTION OF painting real people in their suffering and joy carried his painting technique in new directions. In his desire to communicate his ideas, he simplified his forms and dramatised scenes by unusual lighting and colour. In this street scene he has reduced the features of the people in the street to flat pale areas from which the eyes stare out of formless sockets, their emptiness echoed by the distant windows. In order to emphasise the loneliness and alienation of people, Munch often distorted the perspective of his scenes, thus separating even further the characters from their surroundings.

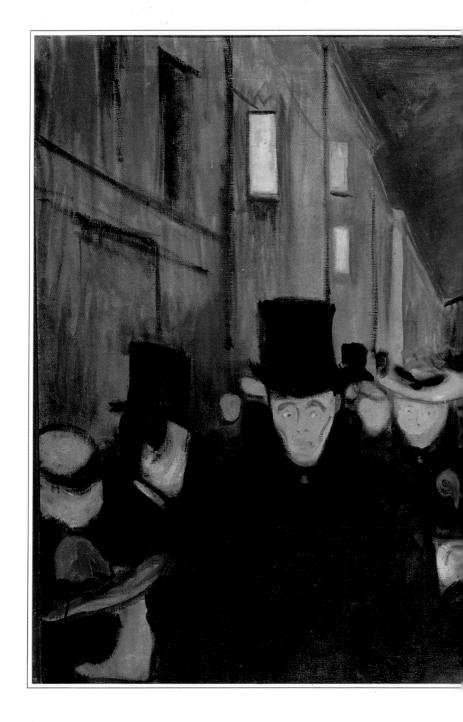

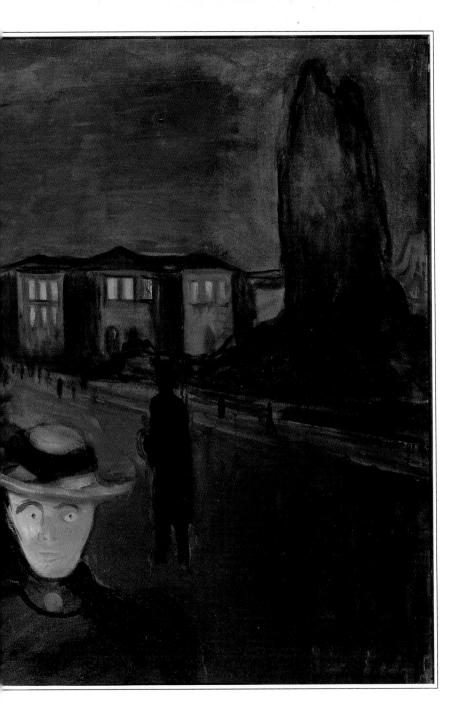

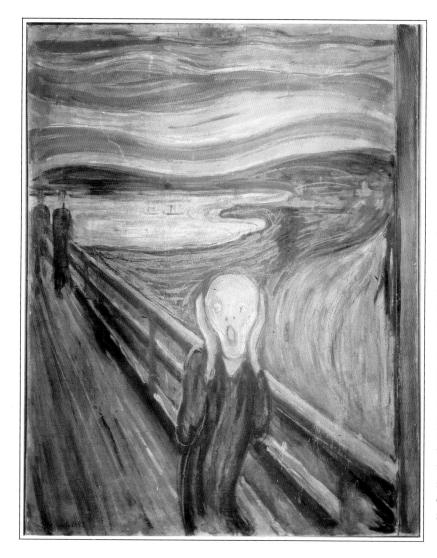

The Scream 1893 Edvard Munch **THE MUNCH MUSEUM/ THE MUNCH-ELLINGSEN GROUP/DACS** 1995

Oil on canvas

THIS IS PROBABLY MUNCH'S most famous work. Its bridge setting is evidently significant, for Munch used it in many other paintings, including Anxiety, painted in 1894, and more happy ones of young women in 1902 and 1903. The Scream, with its winding river and swirling sky, has an intensity reminiscent of van Gogh's Starry Night (see page 10) and was the result of a difficult period when the painter was suffering from neurotic tension and alcoholism. In writing about the picture, Munch described his feelings of fear and anxiety when one evening as he walked across the bridge the sky turned blood red and he experienced 'the great endless scream of nature'.

▷ **Puberty** 1894 Edvard Munch © THE MUNCH MUSEUM/ THE MUNCH-ELLINGSEN GROUP/DACS 1995

Oil on canvas

IN MUNCH'S NEUROTIC imagination sex and death were significantly and disturbingly interlinked. The idea was not uniquely personal to Munch, but was common in the work of many artists of the Romantic era - for example, in Schubert's Death and the Maiden quartet. In this poignant picture of a young girl at puberty, Munch has produced a powerful image of adolescent sexuality in a young person whose maturing thighs are in contrast to the undeveloped breasts and in whom the dawn of sexuality awakens both wonder and fear. The shadow behind the girl and her isolated position in the centre of the bed add to the threatening nature of her setting.

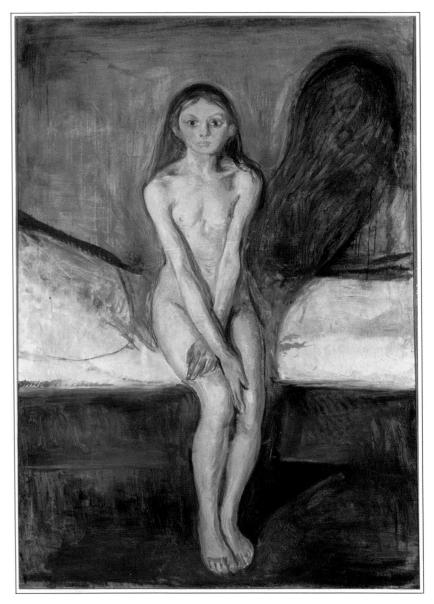

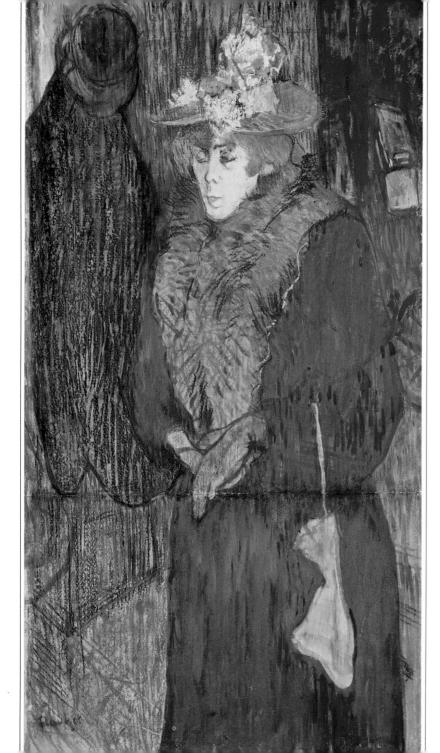

Pastel and gouache on board on panel

THOUGH NOT CONSISTENTLY an Expressionist, there were moments in Henri de Toulouse-Lautrec's work when the emotional response of his spirit overflowed with a compassionate cry for the human condition of his subject. In this case, it is Jeanne Avril, the popular acrobatic dancer of the Moulin Rouge, whom he shows arriving, already tired, for her evening's work in front of the good-time crowd who patronised this popular Paris dance-hall. Lautrec's sympathy for the victims of society came from his own misfortunes. Though a scion of a noble, well-off family, he had the misfortune to break both legs and grew up a stunted adult. He found solace in art and lived in Paris where he frequented dance-halls and brothels, finding friendship among their inmates. Addicted to drink and drugs, he died before he was 40 at his home at Albi in south-west France.

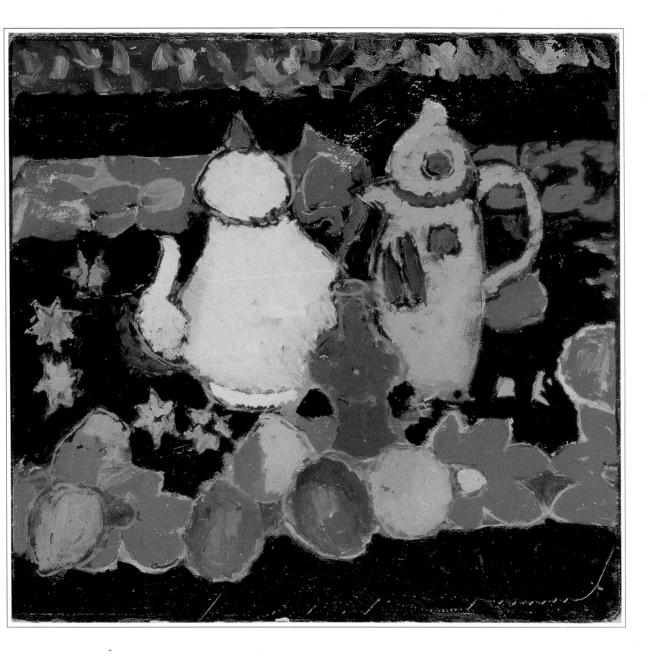

White and Yellow Coffee Pots c.1910 Alexei von Jawlensky (1864-1941) © DACS 1995

Oil on canvas

\lhd Previous page 23

ALEXEI VON JAWLENSKY was an artist who was totally devoted to colour, as distinct from drawing, as the main element in painting, with its own autonomous life. Having taken up painting at the age of 32 after service in the Russian army, he began studying in Munich, where he met Kandinsky, then went to France where his most formative encounter was with Matisse. Having also studied van Gogh's work, Jawlensky devoted himself ever more seriously to the development of his own language of colour. In this painting, the various influences on his work are evident in the strong contrasting colours and the pattern-making, which avoids the convention of perspective and atmosphere and creates a totally selfsufficient world of its own. Spanish Girl 1913
 Alexei von Jawlensky
 © DACS 1995

Oil on canvas

KEEPING CLOSE TO NATURE WAS important to Jawlensky, who based all his work on real objects and was not tempted into the world of abstract art like his friend Kandinsky. Jawlensky was not a realistic painter, but sought what he called synthesis, a compromise where the real thing and the artist's inner vision could be fused into a work of art. At first, Jawlensky looked for inspiration in landscapes, but after about 1909 he was drawn more and more to portraiture, mostly head and shoulder studies like this one, in which there is a certain feeling of El Greco in the large eyes and Mannerist elongation of the head.

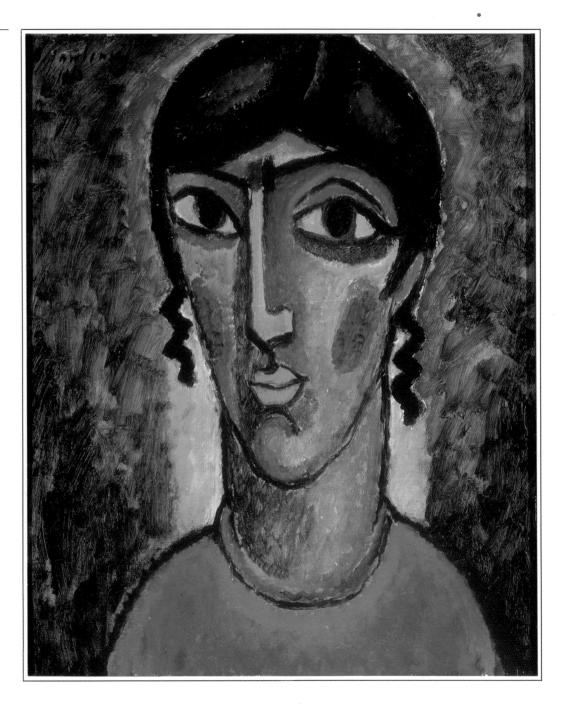

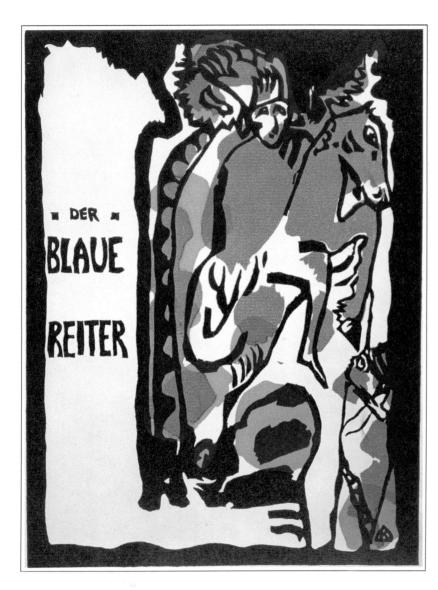

✓ Cover for the review,
Der Blaue Reiter 1911
Wassily Kandinsky (1866-1944)
© ADAGP, Paris and DACS,
London 1995

Colour woodcut

THE BLAUE REITER GROUP was formed in Munich in 1911. and included Kandinsky, Franz Marc and Jawlensky. It was a more sophisticated association than the Dresden group called Die Brücke (The Bridge) and the artists, who had all had professional training, were less inclined to work as a community than those in Dresden. Although the Blaue Reiter group did not issue manifestos about their aims, Kandinsky, who had a natural talent for writing, had a law degree and had lectured at Moscow University, became the voice of Munich Expressionism. He edited the Blaue Reiter Almanac and designed the cover shown here. In stating the views of the artists, Kandinsky hoped that their association would give a material shape to the spiritual kinship that they shared and provide an opportunity to address the public with joint forces.

THE EXPRESSIONISTS 27

 Apocalypse Riders c.1913
 Wassily Kandinsky
 @ ADAGP, Paris and DACS, London 1995

Watercolour and pen

Although Born in Moscow. Wassily Kandinsky got his artistic training in Munich, where he worked with the Phalanx group from 1901 to1908. He was one of the founders of the Blaue Reiter (Blue Rider) group in Munich. At first much influenced by French painters, especially Monet, Kandinsky developed a style of clearly defined forms and colours which became more and more abstract with patches of colour and a free, flowing calligraphic line in drawing, as in this painting. This led him on in the 1920s to pure abstraction, a new form of art which he pioneered with Paul Klee, a fellow-teacher at the influential Bauhaus art centre in Weimar, Germany.

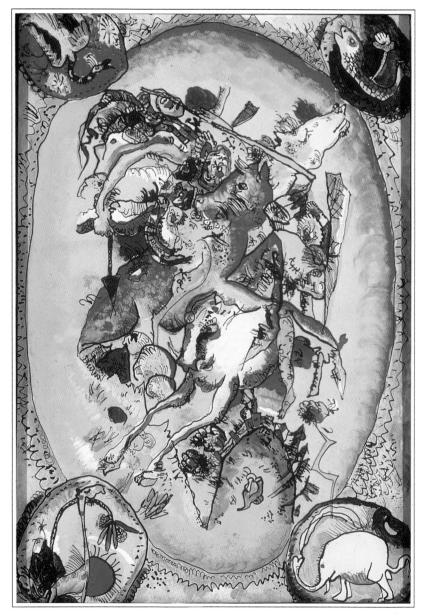

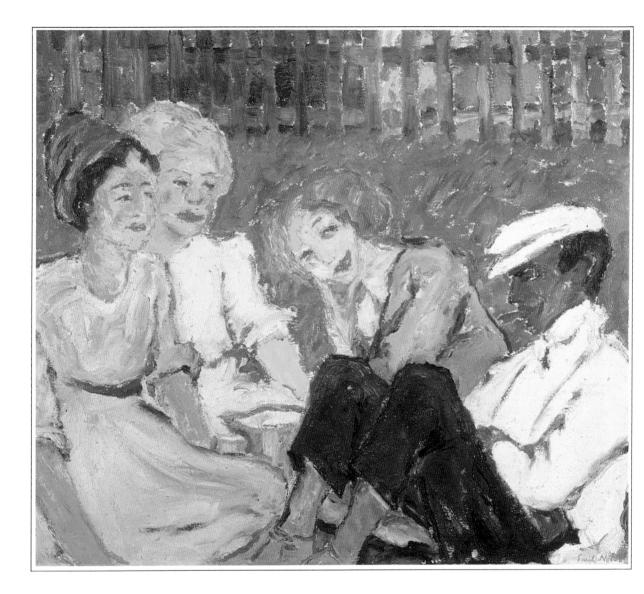

✓ Holiday Guests 1911
 Emil Nolde (1867-1956)
 © Nolde-Stiftung Seebüll

Oil on canvas

EMIL NOLDE, whose real name was Hansen, was brought up on a farm and learned wood carving in a furniture factory in Flensburg and, later, Karlsruhe. He moved to Berlin in1890 as a furniture designer and from there to St Gallen in Switzerland where the beauty of the mountains inspired him to take up painting. At first his personal vision had a strangely anthropomorphic tendency: he even gave his mountains human heads. At the time he painted this sunny picture of a group of friends Nolde was developing a much looser technique than he had earlier employed, using colour in a flatter, more abstract manner, although still keeping to the realistic forms of his subject matter. Though this painting of a lively group of friends suggests he led a sociable life, Nolde tended to be somewhat of a recluse and spent much of his time on the Isle of Alsen away from the artistic milieu of the cities.

Women in a Flower Garden 1916 Emil Nolde

© Nolde-Stiftung Seebüll

Oil on canvas

\triangleright Overleaf page 30

WHILE IN PARIS IN 1900, where he studied at the Académie Julian and learned about Impressionist techniques, Emil Nolde had become particularly interested in the work of Manet and Degas and then in that of van Gogh and Gauguin. Through studying their paintings, he realized that colour could be used to transmit feelings and began to use a bold impasto technique. His colourful, dramatic paintings led to an invitation to join Die Brücke in 1906 and Nolde exhibited with them on several occasions. But he proved too independent and original an artist to stay with a group, and broke away to devote himself to painting religious scenes and, later, the city life of Berlin. In this painting of flowers in a garden Nolde expresses his quasireligious feeling about nature.

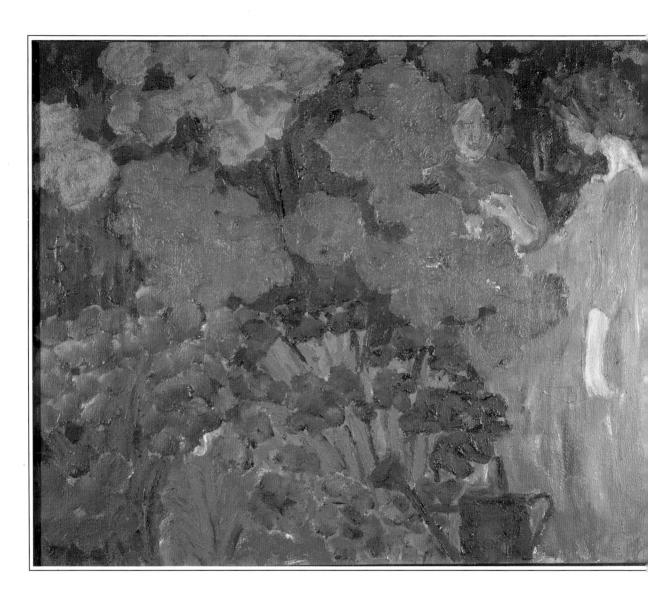

Still Life with a Yellow Horse

1914 Emil Nolde © Nolde-Stiftung Seebüll

Oil on canvas

\lhd Previous page 31

AFTER ABOUT 1910, Emil Nolde's work became more and more abstract in the use of colour which he employed for its emotional impact rather than allowing himself to be guided by local colour. This still life, painted on the eve of the First World War, shows a moment of quiet reflection at a time when Nolde, who was living in Berlin, was caught up in the frenetic life of the capital of the German Empire. Like other artists, Nolde felt the war would be a watershed in German life and would replace the old order with something better. Ironically, in the 1930s, the Nazis classed him as a degenerate painter and destroyed much of his work.

▷ Christ on the Cross 1936 Georges-Henri Rouault (1871-1958)

Gouache

MANY OF THE EXPRESSIONIST painters had a strong religious or mystical motivation in their work, none more so than Georges-Henri Rouault, one of the few French artists to espouse Expressionism. He had studied the production of stained-glass windows in his youth and later joined Gustave Moreau's studio at the Ecole des Beaux Arts in Paris. It was Moreau who moved Rouault towards the use of the brilliant, bold colour which came to characterize his work. The

intense sincerity of Rouault's work came from a strong personal faith and a hatred of hypocrisy and cruelty. The quality and integrity of his work led to many commissions in churches and in book illustration. He also made designs for the Diaghilev Russian Ballet. Although Expressionist in feeling, Rouault's work is less inwardlooking than that of many other artists and is filled with compassion for all his subjects, whether religious personages, clowns or prostitutes.

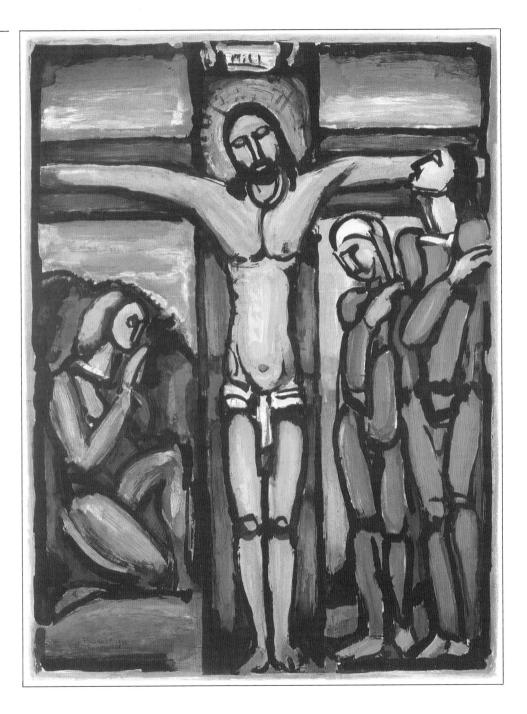

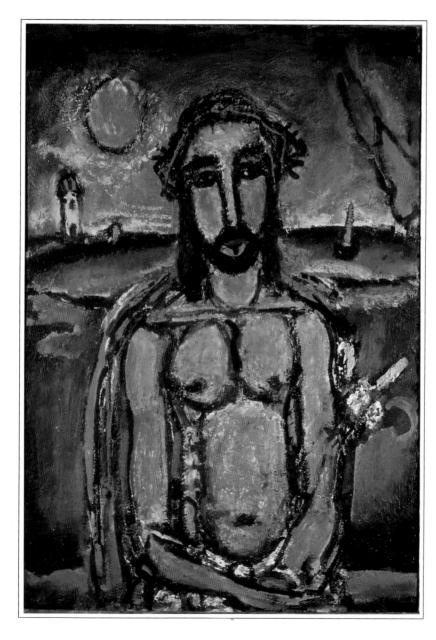

⊲ Ecce Homo c.1930-35 Georges Rouault

Oil

IN ECCE HOMO – 'Behold the Man' - Rouault has avoided the more usual tortured image of Christ as a victim of illtreatment by his fellowmen. Instead, he presents the figure of a quiet, contemplative human being in a setting which suggests that the world is not necessarily an evil place. The heavy black lines round the flattened forms are a reminder of Rouault's long training in stained glass, though they also serve to contain the strong colours, adopted when he was associating with Matisse and the other Fauves, and with whom he exhibited in 1905.

▷ Woman and Dog 1906 Maurice de Vlaminck (1876-1958)

Oil on canvas

MAURICE DE VLAMINCK WAS a natural Fauve and Expressionist. Before a chance encounter with André Derain in a railway accident in 1900, which led to the two setting up a studio together, Vlaminck had been a racing cyclist and mechanic, but had been forced to give up his profession owing to illness. For a while he earned his living playing and teaching the violin, while painting in his spare time. He even wrote novels, for which Derain provided illustrations. He had a natural aptitude for the Expressionist form of art and no inhibitions about applying paint to his canvases with great gusto and insouciance. The first time Vlaminck came face to face with the paintings of van Gogh, he felt he had met a fellow painter with whom he had total empathy. Matisse, who met him at the studio he shared with Derain, helped him to exhibit at the Fauves exhibition at the Salon des Indépendants and also influenced his work.

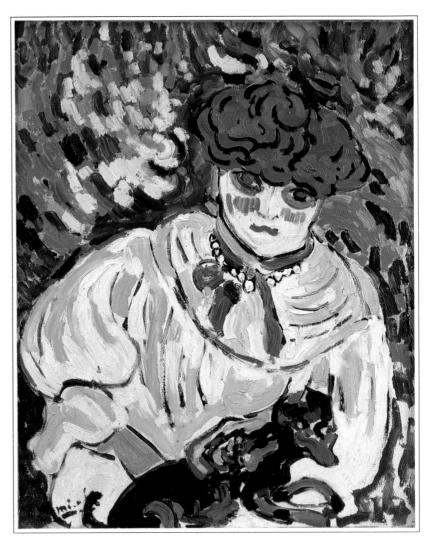

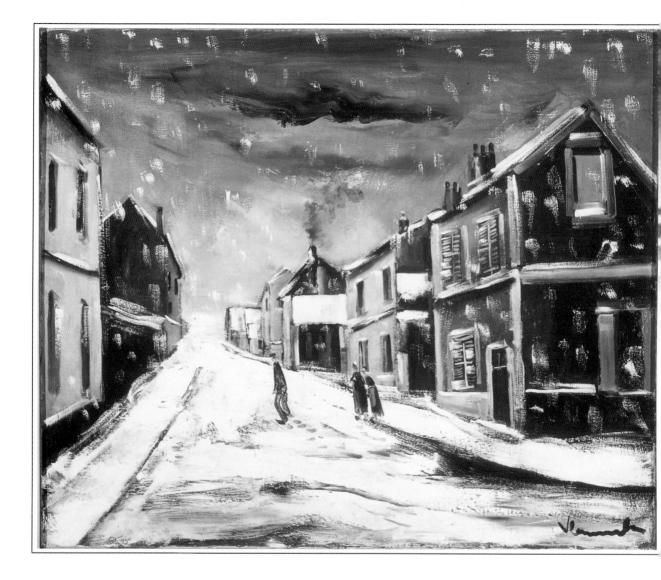

⊲ Road under Snow at Chandais 1925 Maurice de Vlaminck

Oil on canvas

MAURICE DE VLAMINCK'S first one-man show took place in 1910. It was organized by the leading picture dealer Ambroise Vollard, who had obtained a monopoly of Vlaminck's work by the simple means of buying it all. Now able to count on a regular income, Vlaminck could continue working without financial anxiety. His style of painting became gradually more disciplined as he came under the influence of Cézanne. Though friendly with Picasso, he was not tempted into Cubism, which, after one or two Cubist-style paintings, he came to regard as sterile and 'intellectual', and chose to stay close to realism. He especially liked painting landscapes with stormy skies and people with well-defined characters. Unlike many colourist painters, he preserved a feeling of light and dark in his paintings, as in this picture of a town under snow, which has something of the air of a painting by Maurice Utrillo.

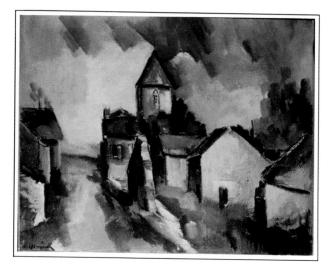

\triangle **Village en Ile de France** c.1920 Maurice de Vlaminck

Oil on canvas

THIS PICTURE of a French village in the countryside near Paris, which had inspired so many Impressionist painters, shows Vlaminck applying paint simply and in broad flat planes in the manner of Paul Cézanne: Vlaminck, though, is more aggressive and looser in his handling of the paint. After military service in the First World War, Vlaminck became anti-militarist and against the industrial

civilization that he observed taking over post-war Europe. His success as a painter enabled him to buy first a house in the country then a farm, La Tourillière, where he remained the rest of his life. He felt no need to travel to Mediterranean locations like other painters, for he believed that if a painter had to travel to renew himself it meant that he really had nothing more to say.

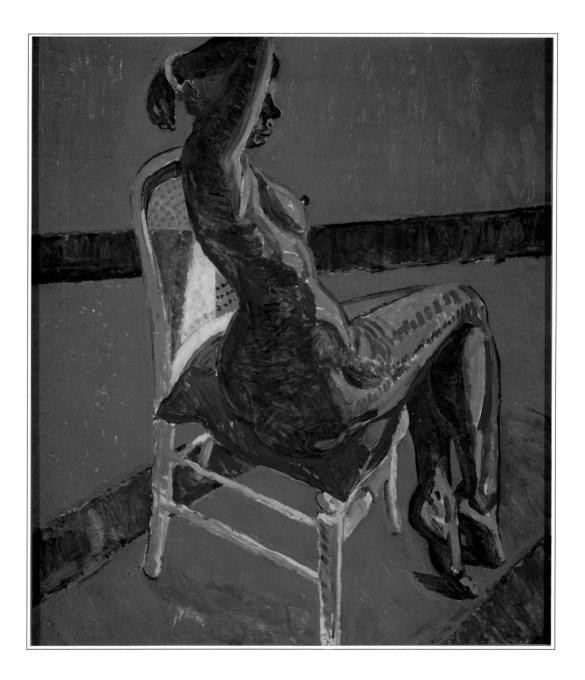

⊲ Nude 1916 Matthew Smith (1879-1959)

Oil on canvas

IN 1916, WHEN THIS splendidly colourful nude was painted, few British artists had taken much interest in the French Fauve movement. Matthew Smith was an exception. He first went to Paris in 1910, where he worked for a time in Henri Matisse's school; the latter's influence was crucial to Smith's future development, as this nude, very reminiscent of the master's Fauve period, shows. Between the wars, Matthew Smith, who was later given a knighthood for his contribution to art in Britain, spent a great deal of time in France where he found a greater acceptance of his work and a sympathetic artistic ambience. His favourite subjects were nudes and flowers, both of which provided many opportunities for displaying the opulent and exotic character of his art.

Two Cats, Blue and Yellow 1912 Franz Marc (1880-1916)

Oil on canvas

 \triangleright Overleaf page 40

FRANZ MARC, with Kandinsky, was editor of the Blaue Reiter Almanac which was published in Munich in 1911 by the group of artists who succeeded Die Brücke as the leading influence in German Expressionist art. Marc, whose father was a painter, first studied art in Munich, but began to develop his own style after a visit to Paris in 1903, where he was deeply influenced by Impressionism. Marc chose animals as his subject because of their true

and beautiful characteristics. His aim was to create an art of simplicity and strong structure in which colour would play a symbolic role: blue for the masculine element, yellow for the feminine, red for the material world, etc. By using colours in this way Marc freed himself from the tie of local colour and his work became more and more abstract. By the time he was called up in 1914 he had abandoned painting real objects. Marc was killed at Verdun in 1916.

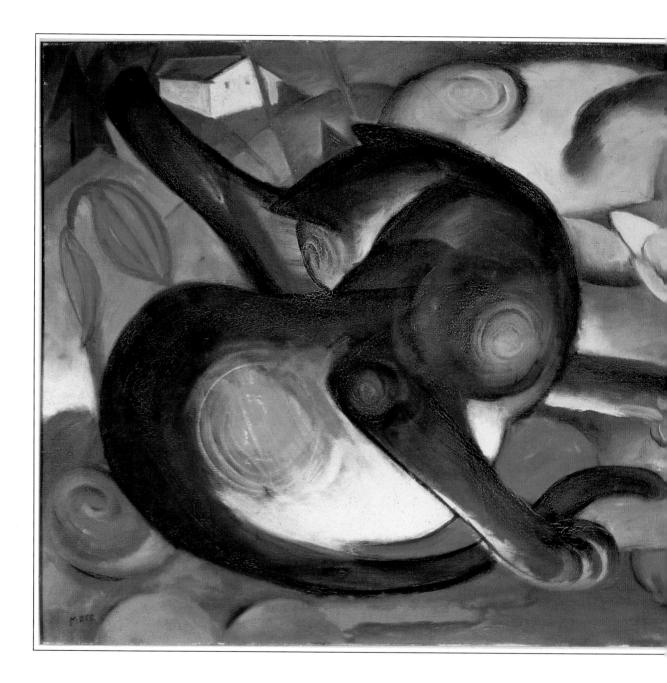

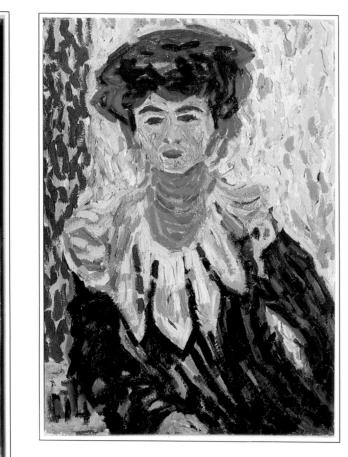

Oil on canvas

DORIS GROSSE, OR 'DODO', was the companion of the young Ernst Kirchner in Dresden while he was studying architecture and painting. In this portrait, painted the year after Kirchner had founded Die Brücke with Fritz Beyl, Erich Heckel and Karl Schmidt-Rottluff, he has painted her in a style borrowed from van Gogh. The paint is applied heavily in pure vibrant colours with the freedom that Kirchner admired in the Dutch painter. The yellow sunflower effect of the collar is perhaps Kirchner's subtle acknowledgement of van Gogh's influence. Kirchner and the other Brücke painters admired the French painters, particularly the Fauves, and invited them to join in their own exhibitions. The invitation was accepted by Derain, Dufy and van Dongen but refused by Matisse, who perhaps felt that he had already progressed beyond the Fauve period.

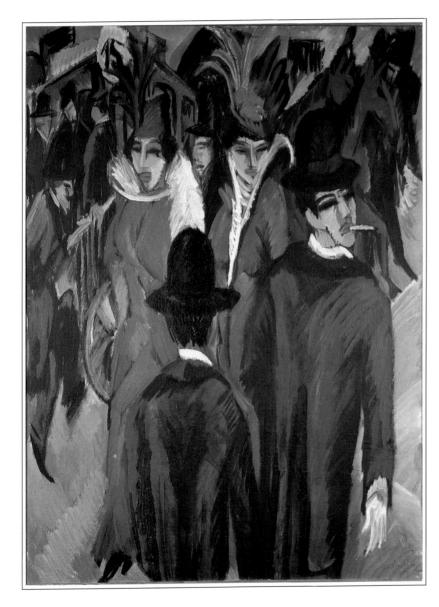

⊲ **Berlin Street Scene** 1913 Ernst Ludwig Kirchner

Oil on canvas

THE ARTISTS OF DIE BRÜCKE wanted to break away from conventional art and to paint in simple forms and primary colours, like the Fauves in Paris. The main difference between the two groups lay in their psychological approach: the French, without the Nordic introspection of Munch and Ensor, painted with Impressionist joie de vivre, while the Germans were more subjective and emotional. While in Berlin Kirchner's style hardened, the rounded forms of nudes and friends he had painted in Dresden became sharper and more angular, perhaps influenced by Cubism as well as by his personal feelings about the life about him. The painter associated the change with his new wife Erna Schilling who, with her sister, was to be an important influence on his life.

▷ **Nude Model** c.1914 Ernst Ludwig Kirchner

Oil on canvas

THE ANGULARITY of this nude figure suggests that Kirchner painted it after he had left Dresden and his wife Dodo and begun to live with Erna Schilling in Berlin. Erna and her sister were more sophisticated than Dodo and influenced his work and view of society. 'The beautiful, shapely, architectonically structured bodies of these two girls replaced the soft Saxon bodies,' he wrote. Erna was also a very practical woman: when Kirchner was recuperating in Switzerland from his mental breakdown she sent him crates of his paintings which inspired him to re-work them and prepare them for the galleries. Kirchner even began to write reviews of his own work which he sent to galleries.

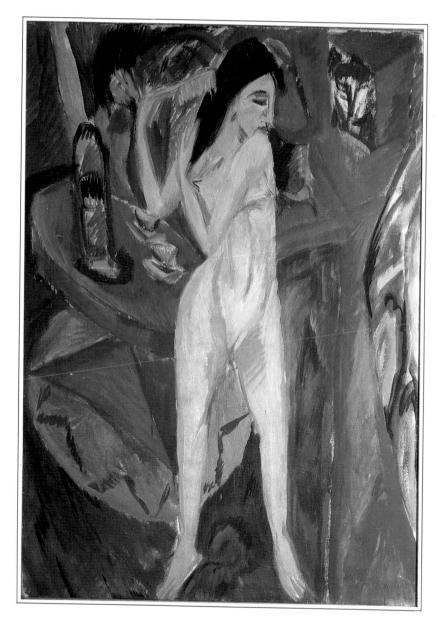

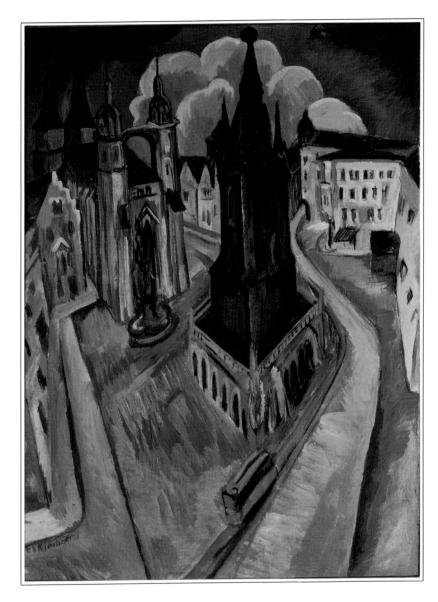

⊲ The Red Tower in Halle 1915 Ernst Ludwig Kirchner

Oil on canvas

IN THIS PICTURE KIRCHNER has turned his attention to the city as a place of human alienation and loneliness. Kirchner spent much of his time in Berlin among prostitutes and other victims of urban society. When war broke out in 1914 Kirchner enlisted as what he described as an 'involuntary volunteer'. By 1915, he had had a nervous breakdown and was invalided out of the army. There followed periods of treatments at various sanatoria, though he continued to paint the life of the Berlin boulevards, with a feeling of repugnance at the well-dressed men and women who paraded the streets while men were dying in the trenches of northern France. Kirchner eventually committed suicide in 1938.

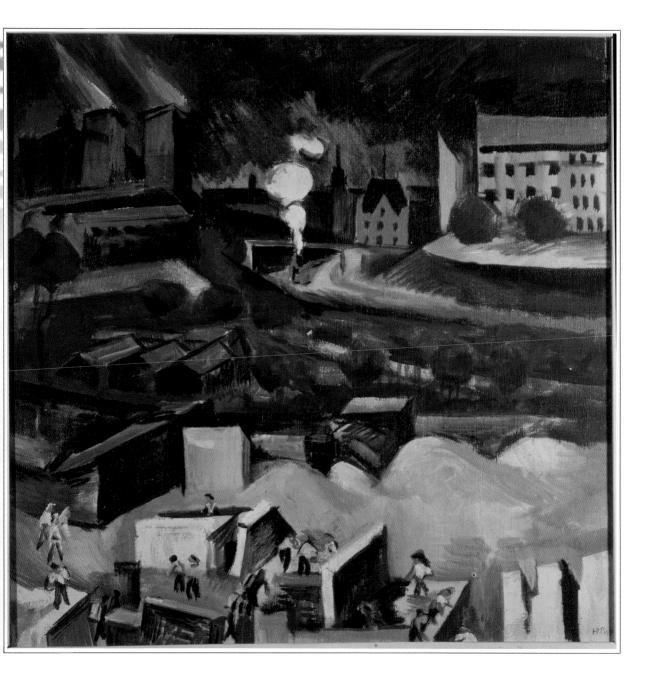

Construction

Max Hermann Pechstein (1881-1955) © DACS 1995

Oil

\triangleleft Previous page 45

MAX PECHSTEIN WAS the only member of Die Brücke to have an academic training. The fact that he was an acknowledged artist who sold his work gave him a certain cachet and he became a leading member of the group for a time; but he himself was eager to break away and explore new ground. He was the first to move from Dresden to Berlin (via Italy and Paris) where he founded, with Ernst Kirchner, a school called Moderner Unterricht in Malerei (Lessons in Modern Painting School). At first, the school's naked women in the life studio aroused police suspicions, but the school came to be accepted. Disenchanted with the artificial city life, Pechstein went to the South Sea islands where he was captured by the Japanese after the outbreak of war in 1914. In this painting, the influence of the Fauves on the German Expressionists shows in the strong use of colouring.

SunriseMax Hermann Pechstein© DACS 1995

Oil

MAX PECHSTEIN'S CLOSE association with Die Brücke was relatively brief. A prizewinning student at Dresden's School of Arts and Crafts, Pechstein was drawn into the group by Erich Heckel in 1906, but went to Italy and then Paris in 1907, and did not return to Germany until 1909. The Brücke artists often painted in the area of the Moritzburg Lakes near Dresden. In the summer of 1910 Pechstein joined them there, producing pictures which many critics consider to be among his best. Pechstein carried on producing paintings reflecting his own inner feelings before nature, travelling as far as the South Seas in search of inspiration. This picture shows Pechstein still painting nature in the 1930s, by which time the Nazis were beginning their purge of the modern art movement in Germany; a year after this picture was painted, Pechstein was forbidden to exhibit his work.

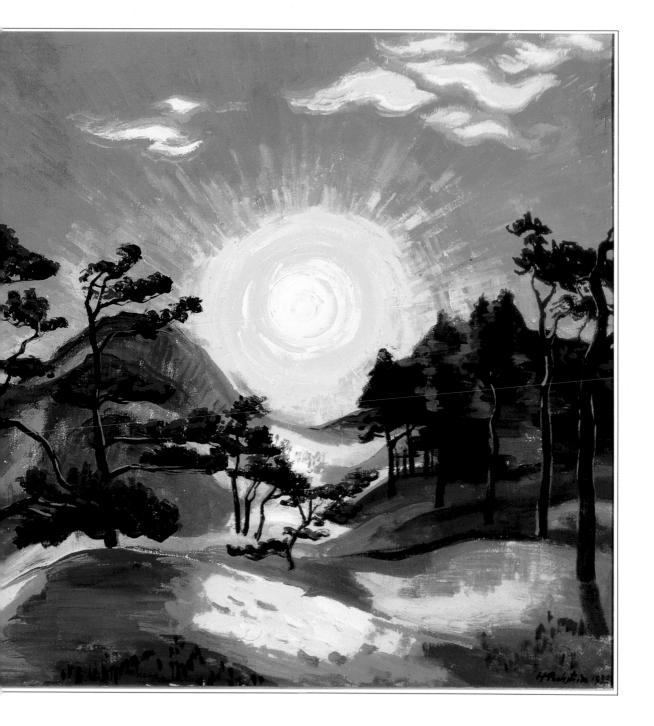

Windmill, Dangast 1909
 Erich Heckel (1883-1970)
 © DACS 1995

Oil on canvas

ERICH HECKEL WAS an architecture student in Dresden when he became one of the founder members of Die Brücke. He believed passionately in the idea of artists working together as a community. He worked tirelessly to this end with his fellow-artists in Die Brücke, managing the group's practical affairs and correspondence. In 1907 he and Karl Schmidt-Rottluff visited Dangast on the North Sea, where they experimented in reproducing as art their direct emotional response to nature. The result was a series of paintings with a broad, simple composition and strong colours. In this picture, the cobalt and cerulean sky, the vermilion buildings and green land make a forceful and uncomplicated statement which demands a direct response from the viewer, and which Heckel hoped would make painting more easily accessible to all.

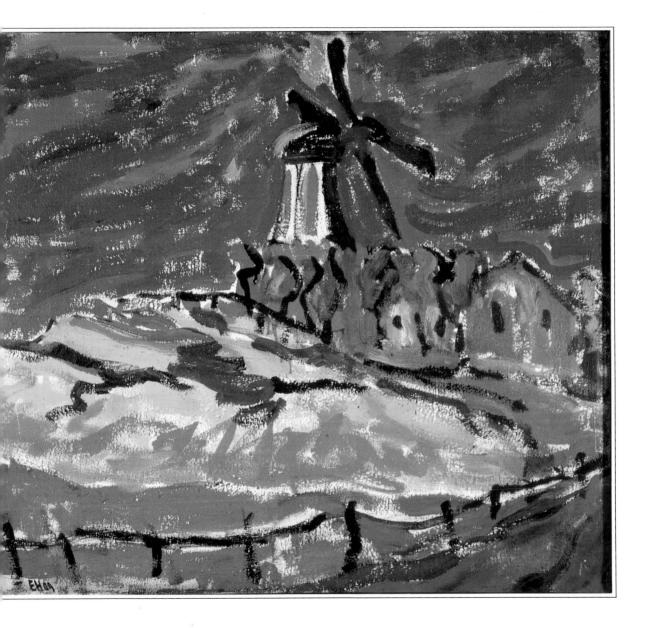

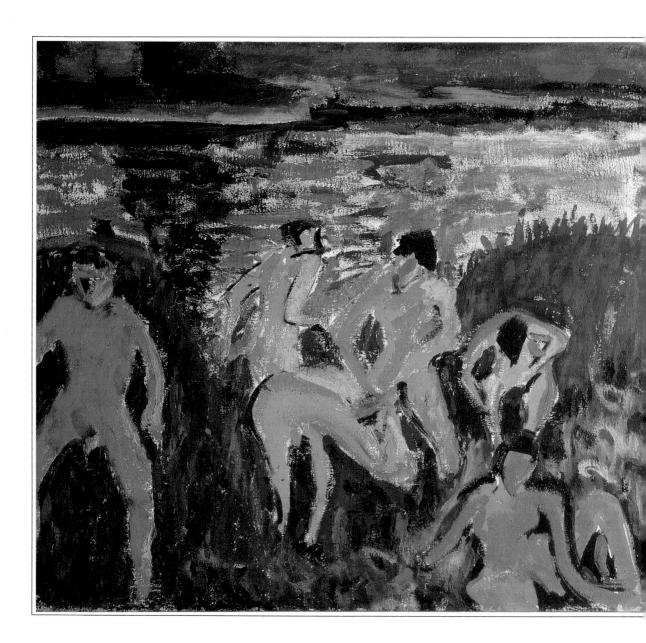

 \cdot

⊲ Bathers in the Reeds 1909 Erich Heckel © DACS 1995

Oil on canvas

THE MORITZBURG LAKES were a favourite summertime rendezvous for the Expressionist artists from Dresden, who would meet there with their models in order to paint and enjoy a Bohemian existence. The paintings they produced there have a cheerful, boisterous quality that suggest that they succeeded in their aim of combining work and pleasure. Artistically, they acquired a greater freedom in handling brushwork as well as colour and thus moved away, as was their intention, from the stiff conventional art that was prevalent in Germany at this time. Their informal social life was also a protest against the prim conventionality of German middle-class society. This painting is a fine example of Heckel's approach to a major theme of his art at this time – human beings and their relationship with nature.

Saxon Village 1910 Erich Heckel © DACS 1995

Oil on canvas

\triangleright Overleaf page 52

THOUGH DRESDEN WAS their main base, the Brücke artists travelled extensively in the neighbouring countryside in search of landscape subjects. Some of them also travelled abroad to see the work of great artists of the past and present. Heckel was one of the most assiduous travellers, visiting Verona, Padua, Florence, Venice and Rome in 1909, as well as painting nearer home at Dangast and the Moritzburg Lakes. Heckel's travels served to confirm his own feeling about painting, which was that it should be an expression of the direct emotional response of an artist to his subject. By simplifying his forms and using bright uncomplicated colours, Heckel hoped to make his paintings more accessible to the public.

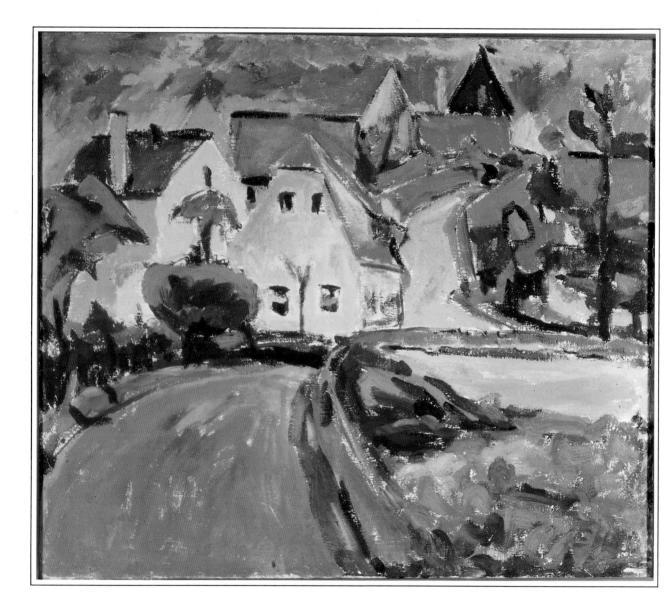

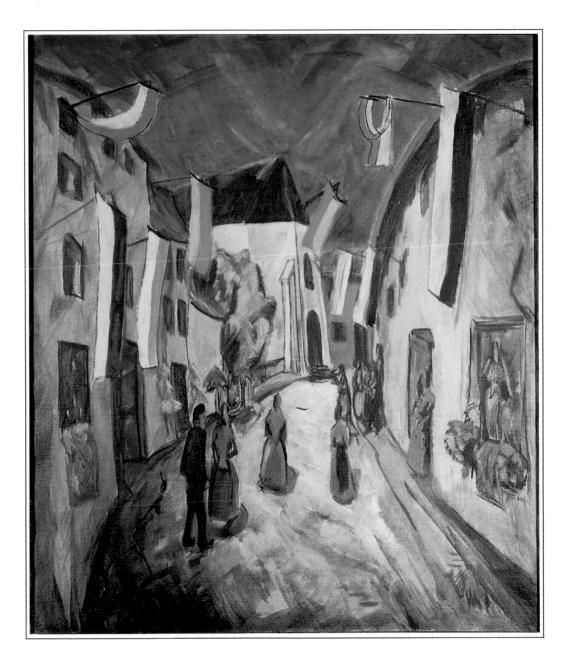

Corpus Christi in Bruges 1914 Erich Heckel © DACS 1995

Oil on canvas

\triangleleft Previous page 53

THIS FESTIVE SCENE was painted on the eve of the First World War. Though there are no obvious indications that a cataclysm is about to overwhelm life in Europe, the heavy sky and foreground shadows may reflect the artist's forebodings about the future. At this time Heckel was himself in a depressed mood, burying himself in the works of Dostoevsky. When war broke out, he immediately volunteered and was fortunate in finding himself in a unit commanded by Walter Kaesbach, an art historian, who enabled him to continue painting portraits of his comrades and landscapes near their camp. The Carpenter
 Karl Schmidt-Rottluff
 (1884-1976)
 © DACS 1995

THOUGH HE WAS A MEMBER OF Die Brücke, the name of which was his suggestion, Karl Schmidt-Rottluff kept himself apart from the communal activities of the group and did not join their outings to the Moritzburg Lakes. His particular friends were Heckel and Kirchner, whose work had an influence on his style, though his own technique was to use thicker and more opaque paint. In 1912, an encounter with a Cubist exhibition in Cologne led him into a more Cubist analysis of forms. Other Brücke artists seeking ways of using their paint more lightly had begun to use petrol as a thinner in order to achieve a more transparent effect.

54

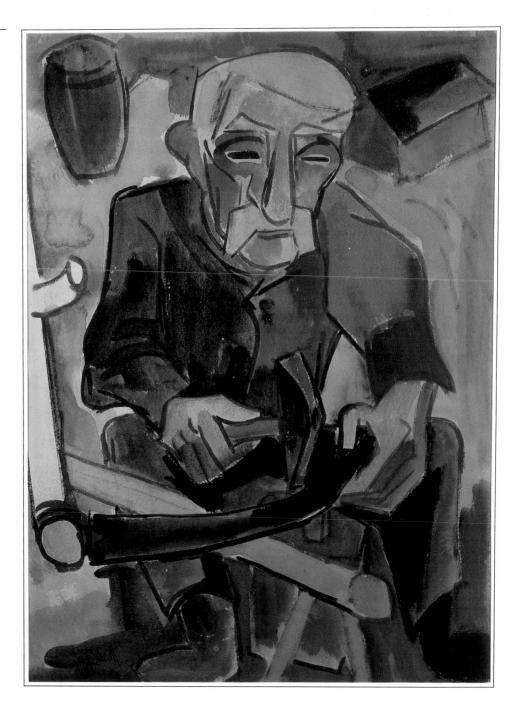

▷ **Ploughing the Fields** 1924 Karl Schmidt-Rottluff © DACS 1995

Watercolour and ink

MOST OF THE MEMBERS OF Die Brücke were unschooled painters and Schmidt-Rottluff was no exception, having done little painting before joining the group. A lack of professional training was considered an advantage, for it meant that the painters were not tied by past disciplines and could react spontaneously to the subjects before them. In this drawing Schmidt-Rottluff has first drawn in the subject, a practice he dropped when he came to the conclusion that there were no lines round forms in nature. Though first attracted to nature as a subject, in later life Schmidt-Rottluff, who was the longestliving of all the artists of Die Brücke, began, like several other Expressionists, to paint religious subjects.

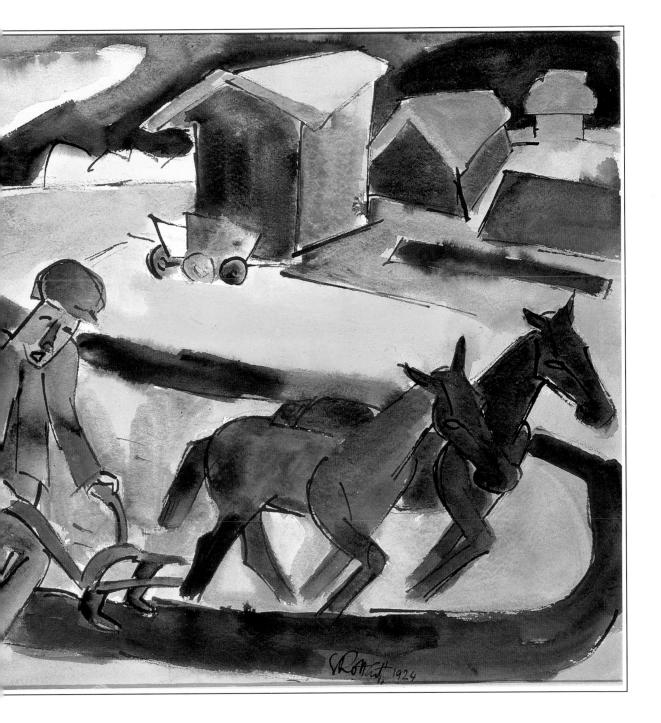

▷ Night 1918-19
 Max Beckmann (1884-1950)
 © DACS 1995

Oil on canvas

MAX BECKMANN WAS a leading German Expressionist and one of many artists who fell foul of the Nazis in the 1930s: he was dismissed as 'decadent' from his teaching position in Frankfurt in 1933. This extraordinarily horrifying painting is Beckmann's response to events in Germany immediately after the ending of the First World War. Between November 1918 and March 1919, when a general

strike was suppressed with great cruelty, Germany was rent by political violence, chaos and famine. Beckmann's painting shows that violence moving off the streets into the home: a family is being brutally assaulted and Beckmann depicts the scene is vivid, sharply-defined areas of line and shade. The artist later explained the painting's purpose as being to 'give mankind a picture of their fate'.

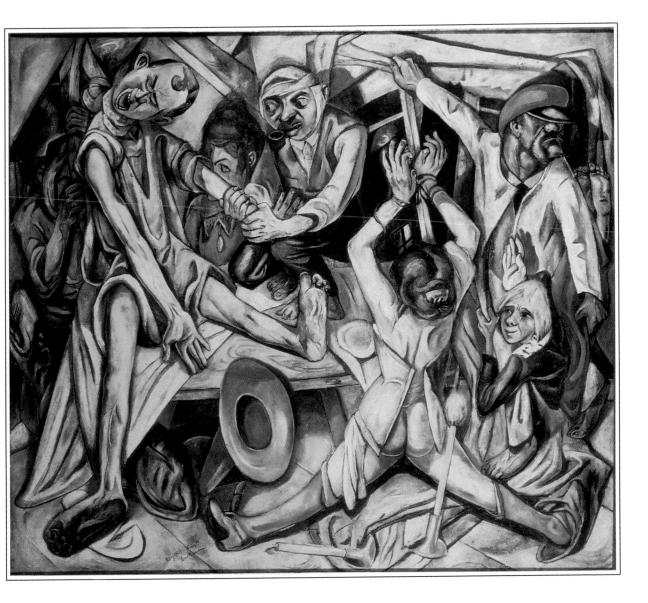

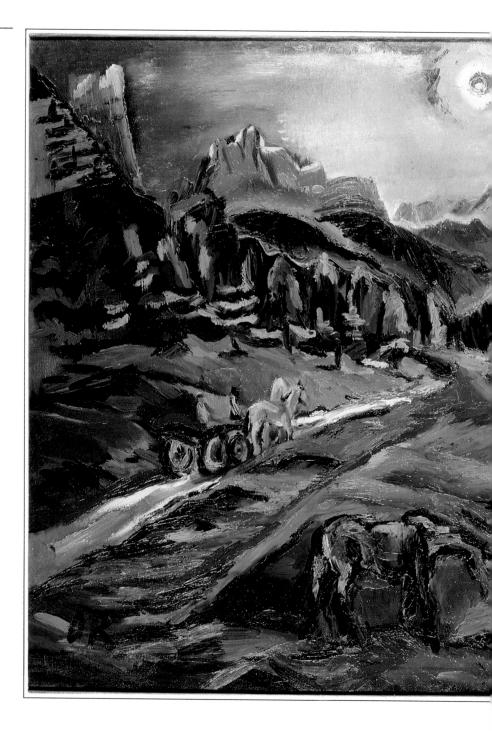

Dolomite Landscape: Tre Croci 1913 Oskar Kokoschka (1886-1980) © DACS 1995

Oil on canvas

\triangleleft Previous page 61

THE IDEA OF COMMUNITIES of artists working together, which was prevalent at the turn of the century and which attracted the members of Die Brücke to the group, also appealed to Oskar Kokoschka. His artistic life began in the Vienna Workshops, where interior design, book illustration and jewellery design, as well as painting, were part of the artistic activity. Kokoschka's particular talent lay in designing posters, though it was his nudes that brought him notoriety because of their 'savage' appearance. Virtually a selftaught painter, Kokoschka learnt much from studying the work of van Gogh and Gustav Klimt, the foremost artist of the Viennese Jugendstil (art nouveau) school. By 1900 he was in Berlin, gaining some renown for his contributions to the art journal, Der Sturm. For some time Alma Mahler, wife of the composer, was his muse, helping him to acquire confidence in developing his own style.

Self-portrait 1917
 Oskar Kokoschka
 © DACS 1995

Oil on canvas

KOKOSCHKA PAINTED this selfportrait after Alma Mahler had left him to marry Gropius, head of the Bauhaus in Weimar. He was depressed at her desertion but continued to paint, using a technique he had created which consisted of applying the paint in short, abrupt strokes which defined the drawing of his forms. The style is very apparent in the jacket of this self-portrait, where swirling white brushstrokes painted on a dark ground create a vibrant and nervous effect. At about this time, Kokoschka also painted an autobiographical picture of a couple with a cat with the woman turning away from the man in a gesture of rejection – a catharsis, perhaps, of his pain at Alma's desertion.

62

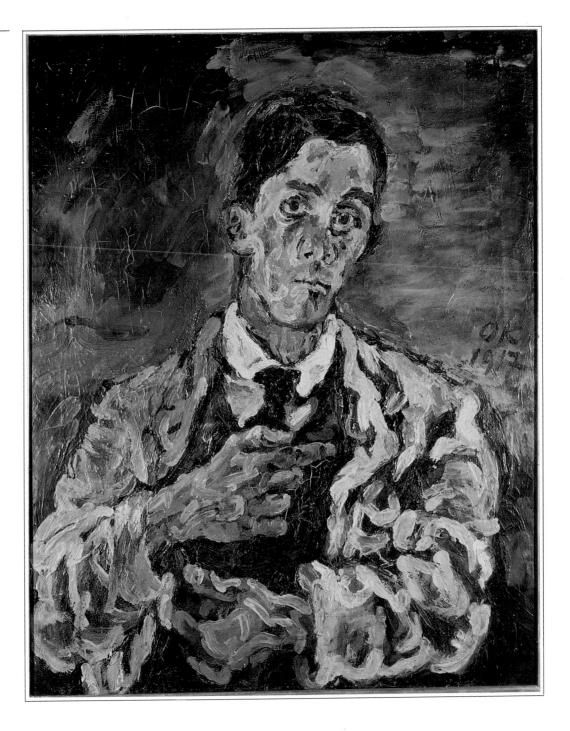

▷ The Power of Music 1918-19
 Oskar Kokoschka
 © DACS 1995

Oil on canvas

AFTER BEING SEVERELY wounded during military service in 1915, Kokoschka went to Dresden to convalesce. His work was now widely accepted, especially in Germany, and in 1919 he was able to obtain an appointment at the Academy of Art in Dresden. With a return of his old self-confidence, Kokoschka found himself able to paint in the forceful and lively manner of his pre-war years. He now moved away from Expressionism, though his style of applying paint thickly and in vivid colours continued to have the abandon typical of the movement, being based on a direct emotional response to the subject.

64

▷ The Synagogue 1917 Marc Chagall (1887-1985)

Gouache on paper on board

THE MOST IMPRESSIVE characteristic of Marc Chagall's work is its autobiographical nature, providing a panoramic vista of a life full of interest. compassion and love. Unlike many Expressionists, whose subjective and introspective exploration of their reaction to the world is often full of disillusionment, Chagall's work expresses joy and a deep faith in life. Born in Russia into a large, poor Jewish family, Chagall inherited the spiritual strengths of both

cultures and remained largely untouched by the intellectual scepticism of Western culture, despite many years spent in France and Germany. When he painted this picture he was Commissar of Fine Arts in Vitebsk, where he had been born. Soon after, he disagreed with Malevich, the Communist head of the arts in Russia, and returned to Paris, where his pre-war studies had steeped him in the artistic language and techniques of the Fauves, and in Cubism.

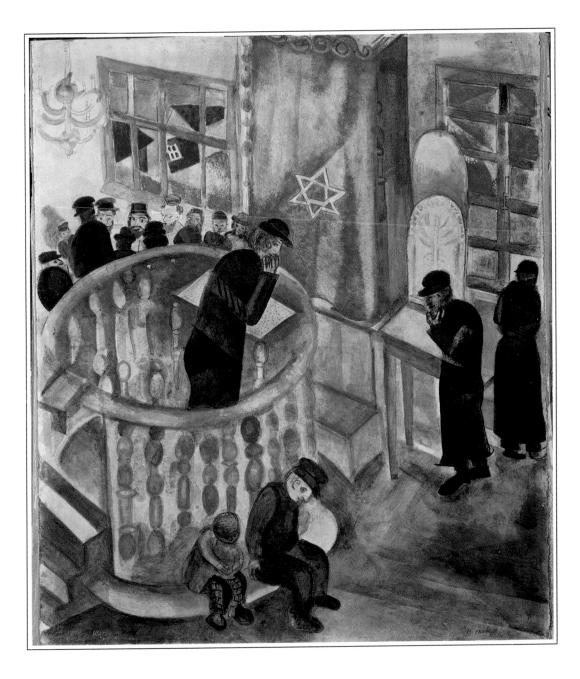

▷ **Marriage** 1918 Marc Chagall

Gouache on paper

THROUGHOUT HIS LIFE Chagall was devoted to two women. The first was Bella Rosenfeld, whom he married in 1915, and the second was Valentina (Vava) Brodsky, whom he married in 1952, eight years after Bella's death. Both women appear in his work and play a romantic role in scenes of love and marriage. This painting celebrates Chagall's love for his wife Bella, depicted in a fantasy style which was to become characteristic of his work. Angels, bouquets of flowers and floating figures appear in much of his work, seeming to express a joy in life which will not allow itself to be weighed down by earthly cares.

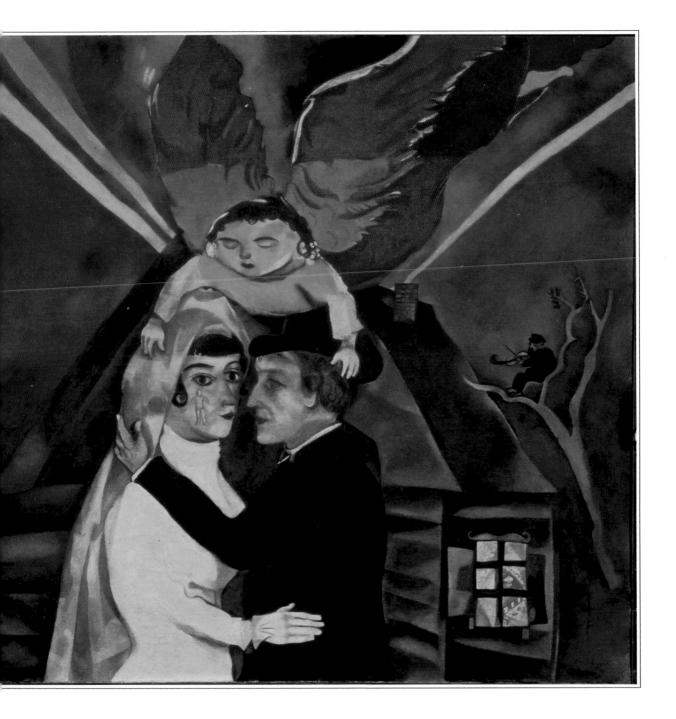

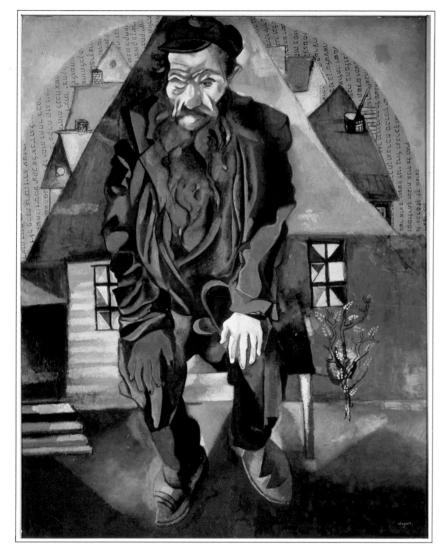

 ⊲ The Red Jew 1914
 Marc Chagall
 © ADAGP, Paris and DACS, London 1995

Oil on canvas

1914 WAS A LANDMARK year for Marc Chagall. After several years of exhibiting in Paris, he had his first one-man show in Berlin. From the great German art centre, he returned to Russia, where he remained for some years, since the outbreak of war prevented a return to Paris. Chagall now felt a need to reappraise his personal philosophy. One result was a series of paintings with strongly Jewish subjects, including several which he named after the dominant colour of the picture: Red Jew and Green Jew, for instance. This one has as its background a Hebrew text, a device he used in other pictures with a Jewish theme. His interest in the culture into which he had been born and in people in general had been confirmed in Paris through his friendship with the highly cultured poet, Blaise Cendrars, with whom he had agreed that the fundamental justification for art was as a means of spiritual communication with people.

Bavarian Landscape 1913
 Heinrich Campendonk
 (1889-1957)
 © DACS 1995

Oil on canvas

THE ARTISTS OF THE Rhineland had their own form of Expressionism, called Rhenish Expressionism, which was influenced by the schools of Dresden and Munich and by the French painters of Paris. For Heinrich Campendonk, who was born in Krefeld and did most of his work there or in Düsseldorf, the most fruitful inspiration came from Cézanne and van Gogh and from his contemporary, the French artist Robert Delaunay and his particular form of Orphic Cubism. Apollinaire described this as a form of painting which did not use existing elements from the visual world but created its own forms. Though not accepting this idea entirely, Campendonk tended in his work towards the use of colour independently of drawing, and to making his paintings convey the idea of the unity of man and nature.

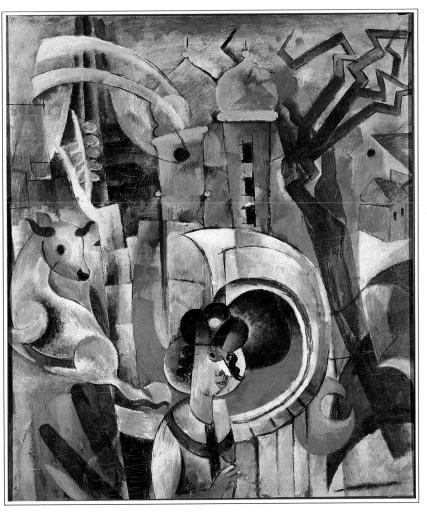

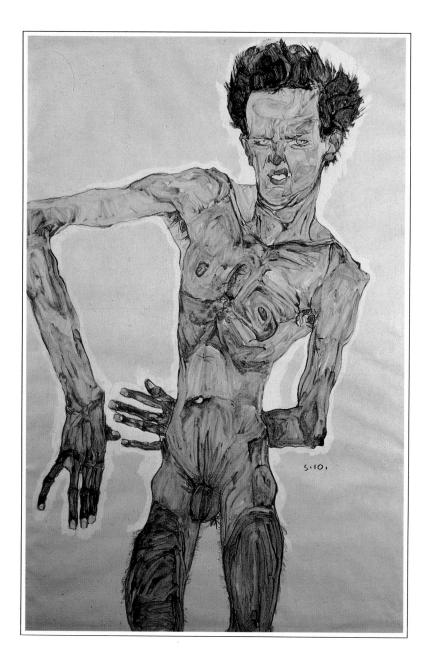

 ✓ Standing Nude, Facing Front (self-portrait) 1910
 Egon Schiele (1890-1918)

Pencil and watercolour

LIKE KOKOSCHKA, Egon Schiele was a protegée of Gustav Klimt in Vienna and became a member of the Vienna Workshops. Klimt's influence as leader of the Viennese art nouveau movement was considerable and is evident in Schiele's work, though his own tortured personality gave his drawing a character of its own. The angular line and smeared paint within the form in this picture are harsh and tormented and, like much of Schiele's work, likely to appeal only to a small coterie of artlovers. Schiele was a painter driven by his own inner compulsions and his work became more and more selfrevelatory, as in his masturbating self-portraits. His view of life was that everything was dead while alive. His own life was short he died at the age of 28 in the great influenza outbreak which followed the end of the First World War.

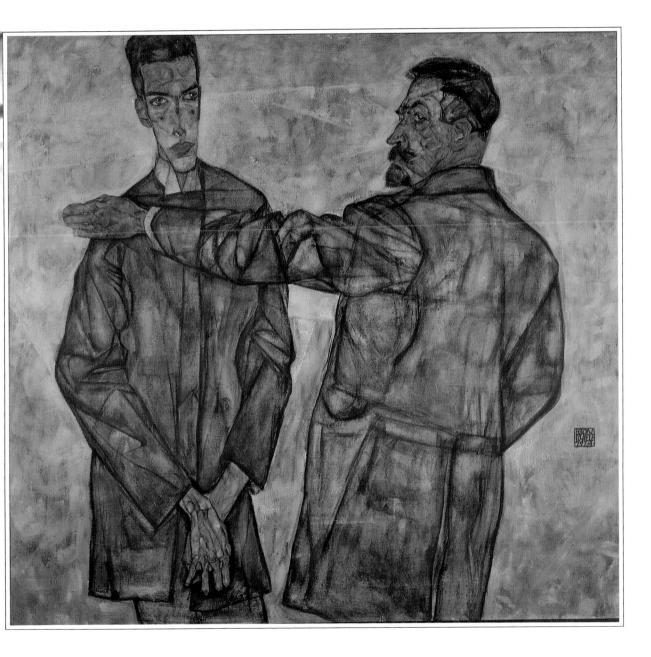

74

Heinrich and Otto Benesch 1913

Egon Schiele

Oil on canvas

\triangleleft Previous page 73

SCHIELE WAS A TALENTED draughtsman with an obsessive style of drawing which gave the line with which he described his nudes and portraits - his main subjects - a harsh and acerbic character. In this double portrait of two friends, he has placed them apart against a wall of broken grey tones which echo the handling in the overcoats. There is little attempt to introduce human dimensions into the characters of the men. whom Schiele shows reflecting his own subjective reactions rather than exploring their personalities. The style makes

Schiele an outstanding representative of the kind of Expressionism which reflects the artist's general revulsion at the human condition, perhaps influenced by the theories of his fellow Viennese, Sigmund Freud, rather than his studies of individual people.

© DACS 1995

Lithograph

BORN IN UNTERMHAUS, Thuringia, Otto Dix did an apprenticeship with an interior designer before moving to Dresden to study at the art and craft school there. He passed through a youthful Expressionist phase before becoming interested in Dada and then in a form of German Cubism called the New Objectivity. His early work in Dresden showed the influence of Die Brücke, but his real awakening to a new form of art came, as with several other

German artists of the time, on seeing an exhibition of the paintings of van Gogh. When war broke out in 1914. Dix enlisted because he wanted to participate in what he thought of as the collapse of an old, outdated society. The Cockerel shows his dynamic style, whose freedom of handling was derived from van Gogh and the Brücke artists, but which also represents his own aggressive response to a world which seemed to him in his youth to be full of evil and horror.

The Little Pastry Cook
 c.1922
 Chaim Soutine (1894-1943)
 © DACS 1995

Oil on canvas

CHAIM SOUTINE ARRIVED in Paris from Russia in 1912 and soon made his mark as an antisocial, anti-conventional art savage. Aloof from the social and artistic milieu of the middle-class intelligentsia, Soutine followed his own star, painting with passion and conviction. Unlike Marc Chagall with his broad wisdom and compassion, Soutine was a rebel and friend of rebels, a close companion of Modigliani and with him of the outcasts of conventional society. In this painting he has picked on one of the overworked, underpaid servants of the bourgeois beau monde, wearing the uniform of the kitchen. His loose style, which annoyed Fernand Léger to the point where he spoke of Soutine's 'smears' - though he admitted that they made a painting - suited his spontaneous emotional reaction to his subjects.

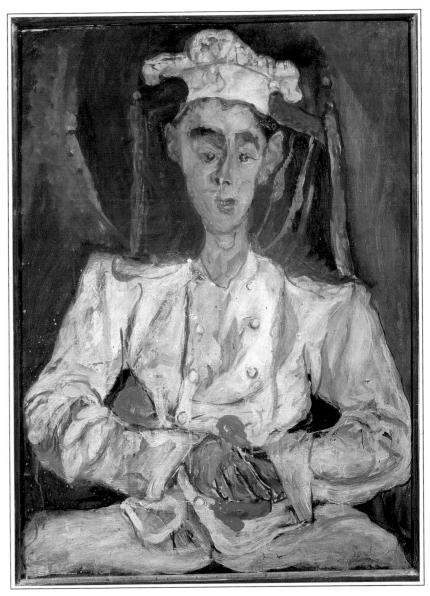

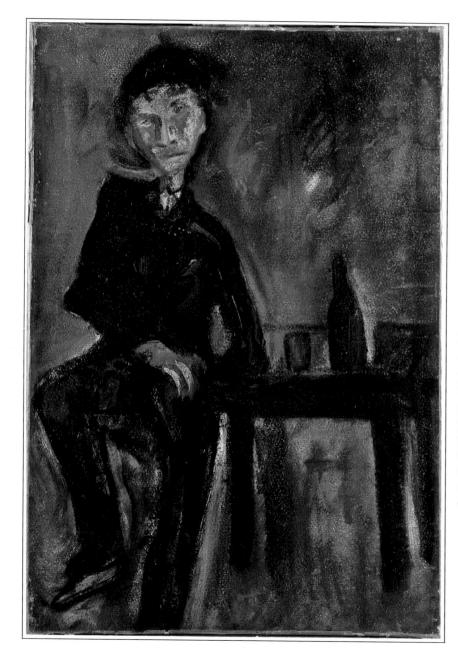

 ✓ Portrait of Monsieur Almenar c.1920
 Chaim Soutine
 © DACS 1995

Oil on canvas

IF CHAIM SOUTINE had a fellow-spirit among the French painters of the past it was probably Courbet, whose Rabelaisian tastes and manners shocked the society of his time as much as Soutine's did in his own time. Courbet also had a robust attitude to painting and ignored the aesthetes and salon critics, and even the people whose portraits he painted. Soutine was not a portrait painter, though he painted telling pictures of people he knew. In this one he has created a powerful impression of a personality, using smudges of paint around the piercing blue eyes and the awkward stance of his subject to convey in more than academic detail the character of the person.

> One of three studies for Figures at the Base of a Crucifixion c.1944 Francis Bacon (1909-1992)

Dil on canvas

FRANCIS BACON WAS A MAN with in intense and personal Expressionist vision. He was elf-taught and his own severest critic, destroying most of his early work and preserving only that part of it which satisfied his feeling for the truth of the painting. In his distorted forms he expressed the agony, pity and compassion that he felt towards humanity around him, much as the Spaniard, Goya, did in his Black paintings. Bacon's technique was his own, and evolved out of a melting-pot of paints, rags and brushes into clear-minded statements that strike a chord in all who see them, even though the initial reaction to his work may be one of revulsion.

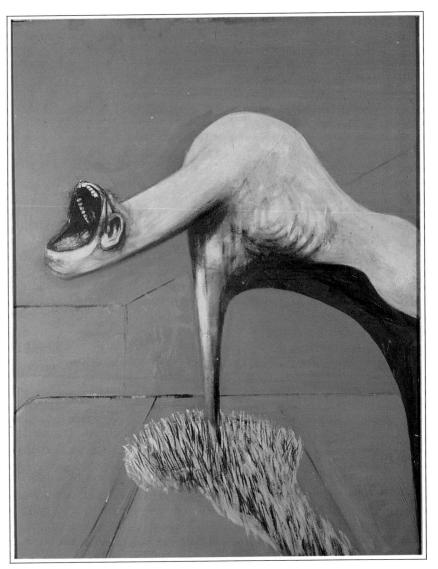

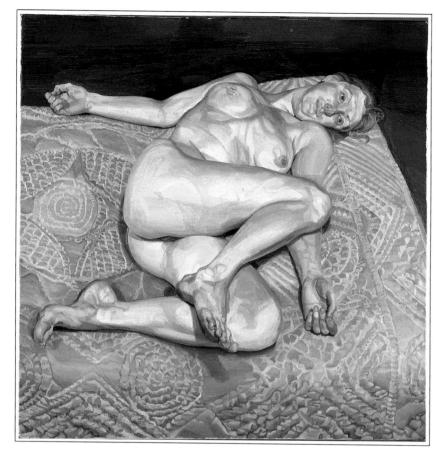

⊲ Night Portrait 1977-78 Lucian Freud (b.1922)

Oil on canvas

LUCIAN FREUD IS one of those artists like Grunewald, the German medieval Expressionist, or Cézanne, who express their feelings about their subjects by a technique of meticulous reality. Grunewald expressed the horror and pity of a crucifixion by details of the tortured body of Christ; Cézanne expressed his feelings about the earth by a careful analysis of the structure of landscape. In Freud's work there is both the Expressionistic feeling of Grunewald and the careful observation of Cézanne. The result is a realism which seems conventional at first glance and then arouses feelings of revulsion. In Renaissance times Freud, with his interest in the human body, might have been a Signorelli, but Freud's bodies have little to do with the Renaissance vision of man as the centre of the universe. Rather, Freud paints flesh without nobility.

ACKNOWLEDGEMENTS

The Publisher would like to thank the following for their kind permission to reproduce the paintings in this book:

Bridgeman Art Library, London /Rijksmuseum Kroller-Muller, Otterlo: 9; /Museum of Modern Art, New York: 10-11; /Koninklijk Museum voor Schone Kunsten, Antwerp: 12-13; /Musees Royaux des Beaux-Arts de Belgique, Brussels: 14-15; /Nasjonalgalleriet, Oslo: Cover, Half-title, 16, 18, 20, 21; /Courtauld Institute Galleries, University of London: 22; /Collection Jawlensky, Locarno: 23; /Collection Hann Becker von Hofheim: 25; /Stadtische Galerie im Lenbachhaus. Munich: 26; /Musee National, Monaco: 27; /Private Collection: 28, 35, 60-61, 67, 78; /W. Lehmbruck Museum, Duisburg: 30, 49; /Heydt Museum, Wuppertal/Index: 31, 52, 63; /Christie's, London: 33, 37, 74; /Staatsgalerie, Stuttgart: 34; /Musee des Beaux-Arts, Le Havre: 36; /Tate Gallery, London: 38, 77; /Oeffentliche Kunstsammlung, Basle: 40; /Thyssen-Bornemisza Collection, Madrid/Index: 41; /Brucke Museum, Berlin: 42-43; /Museum Folkwang, Essen: 44; /Kunstmuseum, Dusseldorf: 45, 50; /Saarland Museum, Saarbrucken: 46-47; /Stadt Museum, Mulheim: 53, 55; /Staedel Institute, Frankfurt: 56-57; /Kunstsammlung Nordrhein-Westfalen, Dusseldorf: 59; /Stedelijk Museum in Eindhoven: 64-65; /Tretyakov Gallery, Moscow: 68-69; /State Russian Museum, St Petersburg: 70; /Kaiser Wilhelm Museum, Krefeld: 71; /Graphische Sammlung Albertina, Vienna: 72; /Neue Galerie, Linz: 73; /Musee de l'Orangerie, Paris: 75; /Musee d'Art Moderne de la Ville de Paris/Lauros-Giraudon: 76;